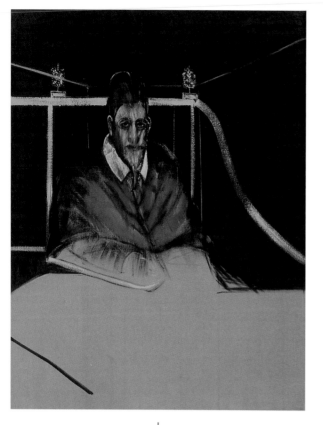

I

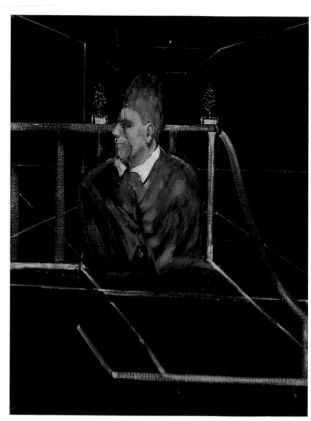

II

V

VI

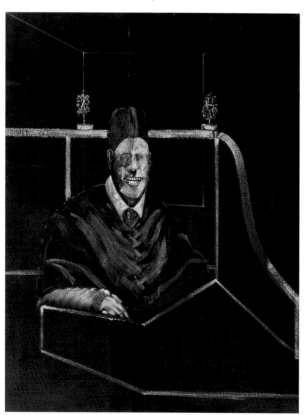

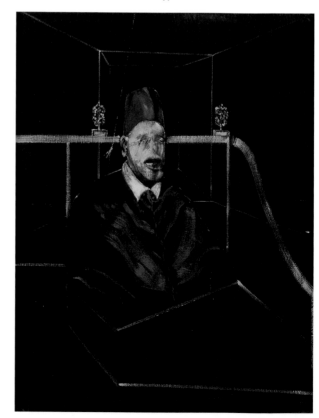

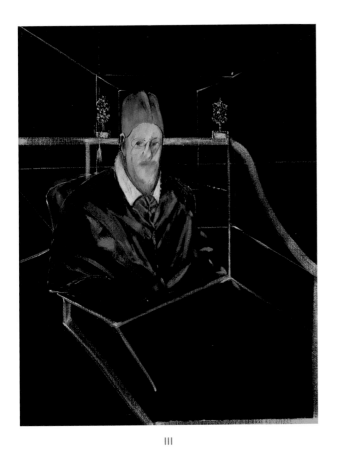

III

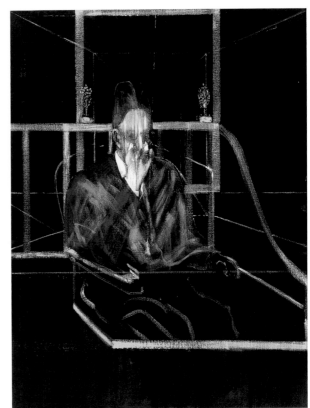

IV

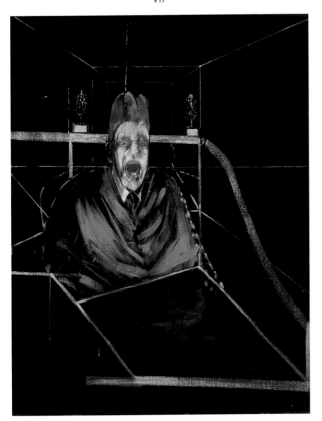

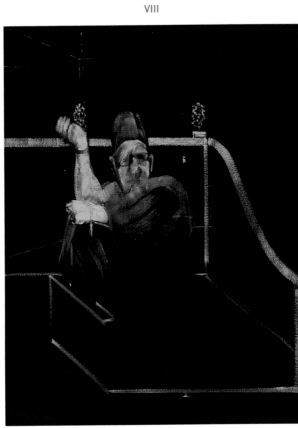

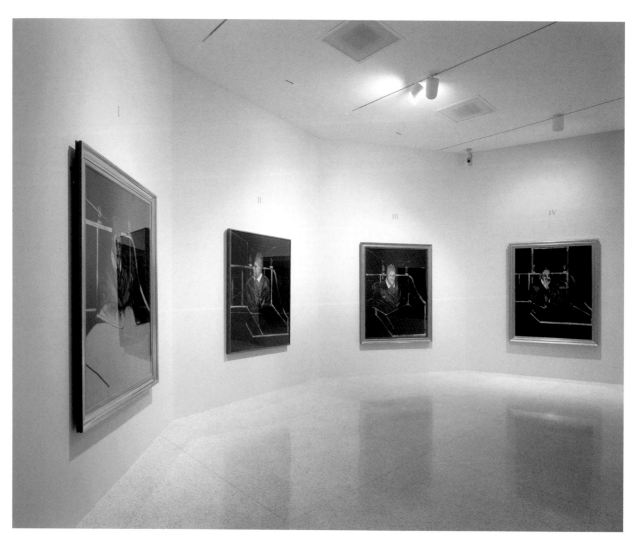

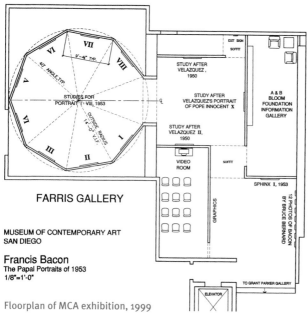

FARRIS GALLERY

MUSEUM OF CONTEMPORARY ART
SAN DIEGO

Francis Bacon
The Papal Portraits of 1953
1/8"=1'-0"

Floorplan of MCA exhibition, 1999

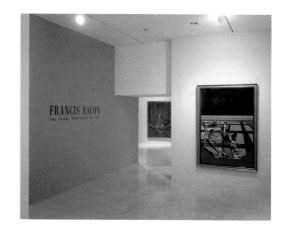

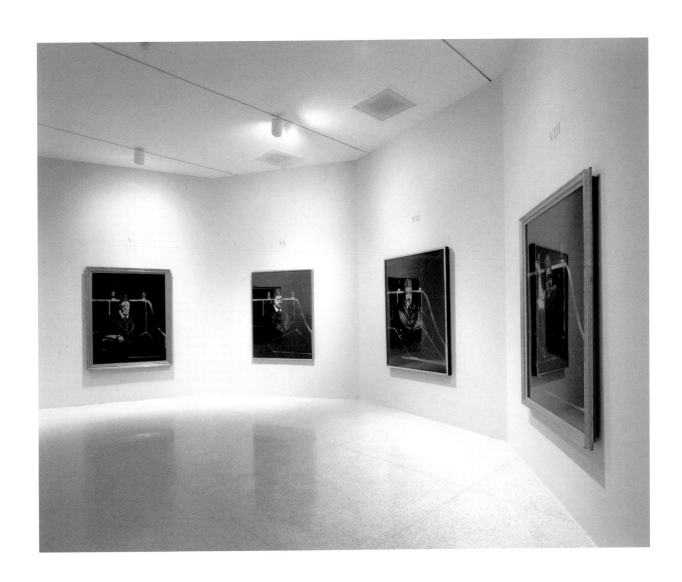

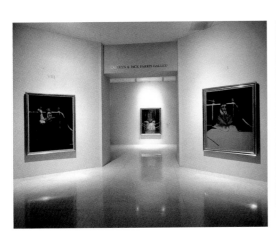

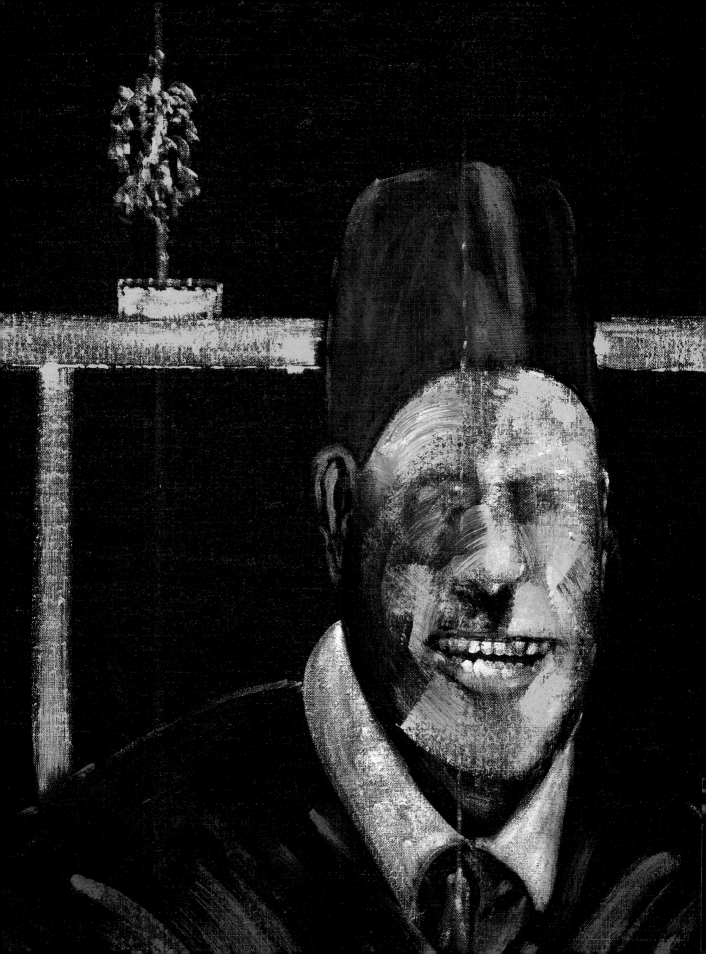

Francis Bacon
The Papal Portraits of 1953

Hugh M. Davies

Museum of Contemporary Art
San Diego

Francis Bacon photographed in his London studio by Hugh Davies, 1973.

for Valerie Beston

We are grateful to the many organizations and individuals whose support has made this project possible. First and foremost, we extend warmest thanks to the international roster of lenders who so generously allowed us to bring their Francis Bacon paintings to San Diego for this, the first opportunity for the public to see the entire series together. We are also enormously indebted to Bacon's gallerists who made this exhibition possible: Valerie Beston, Marlborough Fine Art Ltd., London; Gerard Faggionato, Faggionato Fine Arts, London; and Tony Shafrazi, Tony Shafrazi Gallery, New York. A project of this scope required extraordinary financial commitment, and we thank AT&T for stepping forward early on as the exhibition's Presenting Sponsor. Additional major support came from an indemnity by the Federal Council on the Arts and Humanities and a California Challenge Grant from the California Arts Council, the latter grant matched by very generous contributions from Lucille and Ron Neeley, The British Council, and the A & B Bloom Foundation. Virgin Atlantic Airways, the exhibition's official airline, provided critical transportation services. We are extremely grateful to Sue K. and Charles C. Edwards, whose generous contribution made possible this handsome publication.

The catalogue is the work of our outstanding designer, Susan E. Kelly of Marquand Books, and photographer Philipp Scholz Rittermann, who beautifully documented the exhibition. As always, each member of our staff—curatorial, education, development, administrative, building, and security—have been exemplary in pulling together such a complex project. I am particularly grateful to Andrea Hales, Anne Farrell, Kathlene Gusel, Seonaid McArthur, Virginia Abblitt, Charles Castle, Elizabeth Armstrong, Jane Rice, and Mary Johnson, who coordinated so many details in bringing these paintings to San Diego. I am also thankful to the participants of our March 1999 symposium, Ernst van Alphen, James Demetrion, Richard Francis, and David Sylvester (in absentia), whose papers presented important insights into the work of Francis Bacon.

I was fortunate to have the opportunity to interview Francis Bacon several times in 1973, and one of those previously unpublished interviews is included in this publication. Since I was a graduate student, I have envisioned a moment when all of Bacon's papal portraits of 1953 could be seen in one place, at one time. It is my great pleasure and honor to have been able to realize such a long-held dream here at the Museum of Contemporary Art, San Diego. The occasion of a six-month sabbatical from the Museum provided me with the time to update and reinvigorate my work on Bacon, which led to the creation of this exhibition. I am grateful to the Museum, its Trustees, and to the National Endowment of the Arts for allowing me this opportunity.

HMD

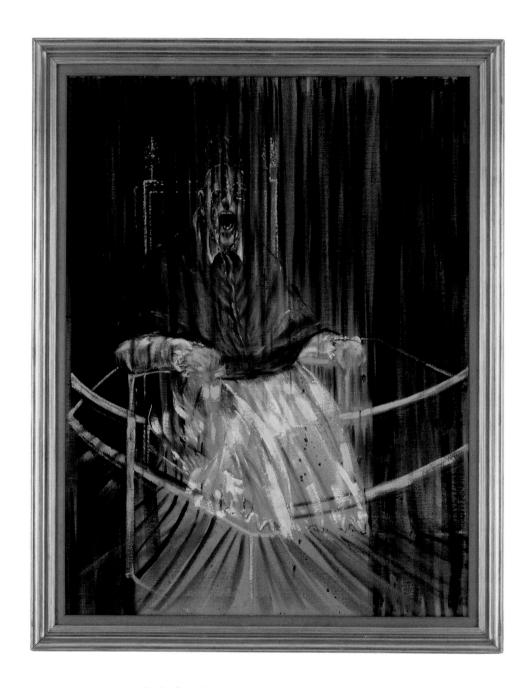

Study after Velázquez's Portrait of Pope Innocent X, 1953
Oil on canvas
60¼ x 46½ inches
Nathan Emory Coffin Collection of the Des Moines Art Center,
Purchased with funds from the Coffin Fine Arts Trust

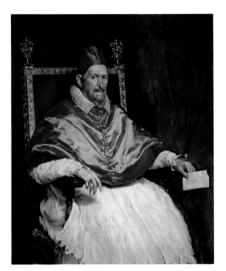

Diego Rodriguez de Silva y Velázquez,
Portrait of Pope Innocent X, 1650
Oil on canvas, 55⅛ x 47¼ inches
Courtesy Arti Doria Pamphilj, Rome

Throughout his long career, Francis Bacon (1909–1992) stead-fastly focused on the human figure as the subject of his paint-ings. Unlike other major artists of his time who reveled in abstraction, such as Jackson Pollock and Barnett Newman, Bacon never deviated from his commitment to making images of people. Yet while extending the timeless tradition of figura-tion, he invented profound and startling new ways of portray-ing people as he distorted the inhabitants of his painterly world in order to "unlock the valves of feeling and therefore return the onlooker to life more violently."[1]

Bacon's most recognizable image, and hence most famous painting, is the screaming pope of *Study after Velázquez's Portrait of Pope Innocent X* of 1953. The picture was inspired by Diego Velázquez's extraordinarily lifelike portrait of a powerful and unscrupulous pope who duplicitously took the name Innocent. Painted in 1650 at the height of the Baroque period, shortly after his arrival in Rome from Spain, it was Velázquez's eminently successful attempt to rival the portraiture of Titian and the great painters of Italy. The subject of the painting is arguably the most powerful man in the world. He sits confidently on the papal throne, fully at ease *ex cathedra*—literally, from the cathedral seat—as God's representative on

earth. The true brilliance of Velázquez's accomplishment in this painting is to have satisfied his demanding papal client with a flattering, beautifully rendered portrait while at the same time passing on for the ages the unmistakable hint of corrupt character and deep-seated deceit behind that well-ordered and stern façade.

"Haunted and obsessed by the image . . . by its perfection,"[2] Bacon sought to reinvent Velázquez's *Portrait of Pope Innocent X* in the papal portraits that form the focus of this book. In the great painting from the Des Moines Art Center, the *Study after Velázquez's Portrait of Pope Innocent X*, Bacon updates the seventeenth-century image by transforming the Spanish artist's confident client and relaxed leader into a screaming victim. Trapped as if manacled to an electric chair, the ludicrously drag-attired subject is jolted into involuntary motion by external forces or internal psychoses. The eternal quiet of Velázquez's Innocent is replaced by the involuntary cry of Bacon's anonymous, unwitting, tortured occupant of the hot seat. One could hardly conceive of a more devastating depiction of postwar, existential angst or a more convincing denial of faith in the era that exemplified Nietzsche's declaration that God is dead.

In Bacon's words: "Great art is always a way of concentrating, reinventing what is called fact, what we know of our existence—a reconcentration . . . tearing away the veils that fact acquires through time. Ideas always acquire appearance veils, the attitudes people acquire of their time and earlier time. Really good artists tear down those veils."[3]

In much the same spirit that Velázquez went to Rome, determined to vie with the state portraits of Titian and remake them in the image of his time, Bacon's papal variations are his attempt to reinvent or reinterpret Velázquez's image in a way that would be valid for the mid-twentieth century. To accomplish this reinvention, Bacon essentially replaced the grand, official state portrait with an intimate, spontaneous, candid camera glimpse behind the well-ordered exterior. While Velázquez portrayed the pope *ex cathedra*, Bacon might be said to have captured him *in camera*—as if behind a closed door or through a one-way mirror. While Innocent directly confronts his audience with a confident, almost contemptuous

gaze, Bacon's pope, preoccupied by pain, seems oblivious to observation.

In achieving his updated portrait, Bacon grafted a graphic film image onto the staid Baroque prototype. The specific source for the pope's screaming mouth, shattered pince-nez, and blood-dripping eye is a black-and-white still from Sergei Eisenstein's classic 1925 film, *Battleship Potemkin*. Bacon first saw the film in 1935, viewed it frequently thereafter, and throughout his career kept the photographic still like a touchstone in his successive studios. The particularly vivid scene in the film depicts the panic of a woman at the instant she is shot in the eye by czarist troops while descending the long flight of steps in Odessa leading from the upper town to the working-class dockland. For Eisenstein—and later Bacon—the woman's spontaneous reaction becomes the compellingly apt metaphor for a world turned upside down. Nothing could be further from the supremely confident composure of Innocent X.

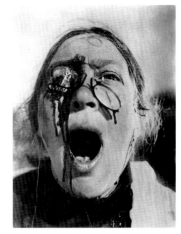

Still from Sergei Eisenstein's 1925 film, *Battleship Potemkin*
Courtesy The Museum of Modern Art Film Stills Archive

A further art historical source for Bacon's depiction is Titian's *Portrait of Filippo Archinto* (circa 1551–62). This picture, which in pose anticipates the Velázquez portrait of 1650, is unique for the mysterious transparent curtain hanging across the right half of the painting. The diaphanous veil bisects the cardinal's right eye and blurs the hand and side of the face behind the transparent curtain. Bacon, in photographic fashion, duplicates this blurred, smeared appearance in his portrait as if the curtain had been hung across the entire painting, and explains the effect by claiming, "I wanted to paint a head as if folded in on itself, like the folds of a curtain."[4]

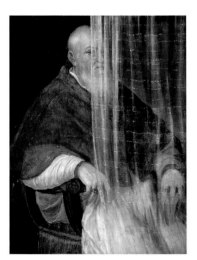

Titian (Tiziano Vecelli), *Portrait of Filippo Archinto,* circa 1551–62
Oil on canvas, 45¼ x 35 inches
Courtesy The John G. Johnson Collection, Philadelphia Museum of Art

It also gives Bacon's painting the contemporary feeling and insubstantial appearance of a film image projected onto the folds of a closed curtain. A personal source for the ubiquitous scream and oppressive evocation of claustrophobia in Bacon's art of this time may well be the asthmatic condition that exempted him from military service during World War II and continued to affect him throughout his life.

The historic significance of the recent exhibition resides primarily in the fact that the eight papal portraits that comprise the stunning *Study for Portrait I–VIII* series (the longest series of Bacon's career) had never before hung in the same room. The paintings were made in the summer of 1953 in anticipation of Bacon's first exhibition outside England, which took place at Durlacher Brothers gallery in New York in October and November that year. Although all eight studies were sent to New York, only five (numbers I, IV, V, VII, and VIII) were included in the show.

Study for Portrait I began as a likeness of Bacon's friend, the art critic David Sylvester, but at about the fourth sitting the figure turned into a pope. Over the next two weeks, working feverishly and with great spontaneity and confidence, Bacon completed the seven additional variations that form the series *Study for Portrait I–VIII*. The very similar settings of these eight pictures can be characterized as spare, deep, dark interior spaces defined by sketchy white recessional lines that culminate in rear walls parallel to the picture plane. The papal throne is distilled to the bold, broad strokes of gold paint that describe a tubular structure more reminiscent of a brass bed frame, were it not for the paired ornate finials of the chair back that bracket the papal head in every picture. While the lower third of *Study for Portrait I* is left as virtually bare, unprimed canvas, the remaining pictures in the series have uniformly dark backgrounds upon which the cursory construction lines of golden railings variously demark enclosing, coffinlike boxes that conceal the respective popes below the waist.

In *Study for Portrait I,* a surprisingly calm pope, who has been coaxed into being with exceptional economy of means by large brushes and thin paint, stares benignly out at the

viewer from behind his wire-rim spectacles. Apart from his Potemkin pince-nez, he closely resembles the David Sylvester we recognize from contemporary photographs. Subsequent pictures in the series appear to capture various moods and aspects of the pope's personality, as if we were looking at an enlarged contact sheet of a prolonged portrait photo shoot. It is also possible that the series represents a collection of eight distinct papal portraits, a picture gallery of popes, as it were, rather than sequential images of the same subject. Bacon declared at the time that he painted in series partly because he saw the images in a shifting way and almost in shifting sequences. The pictures are clearly painted one after the other, with the previous one suggesting the next.[5]

David Sylvester

To summarize the series: following the formal benignity of the first study, the pope turns to his right to offer a profile view in the second, appears guarded in confronting the painter in the third, apparently sneezes or guffaws in the fourth, laughs heartily baring his teeth like Teddy Roosevelt in the fifth, begins to open his mouth as if to speak in the sixth, delivers a full-blown scream in the seventh, and dismisses the painter with an "Italian salute" in the final frame. Apart from the first study, a string ending in a tassel (like a blind cord hung above a proscenium) irritatingly hangs across or beside the pope's face in every frame. This surrealist detail of the dangling tassel—like a fly annoying the popes—becomes a staple in Bacon's subsequent work of the

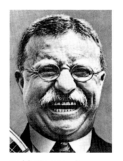

Teddy Roosevelt

1950s as does the hanging, naked lightbulb for his paintings of the 1970s and 1980s.

The inspiration for Bacon's serial portraits is undoubtedly photography. While film footage and contact sheets might have triggered his use of seriality, most likely his crucial model was the collection of multiple-image photographic studies of the 1880s contained in Eadweard Muybridge's famous book, *The Human Figure in Motion*. Muybridge's photographs intrigued Bacon, and many of his paintings throughout his career closely relate to

the photographer's seminal work. Shortly after the series was completed, Sam Hunter wrote incisively of these portraits: "Technically, Bacon has been audacious enough to try for one continuous cinematic impression in his popes—an entirely new kind of painting experience. He combines the monumentality of the great art of the past with the 'modernity' of the film strip."[6]

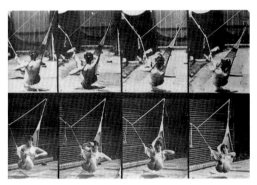

Eadweard Muybridge, *The Human Figure in Motion, Woman Lying Down in Hammock,* plate 174 (detail), 1884–85

Further illuminating the nine papal portraits of 1953 are two recently found papal paintings that predate 1953. *Study after Velázquez* and *Study after Velázquez II*, both painted in 1950 if not earlier, anticipate the Des Moines papal portrait, sharing the screaming subject and curtained setting. The first study was thought to have been destroyed by the artist in 1950 and is so documented in Alley and Rothenstein's definitive catalogue raisonné of 1964.[7] History is indeed fortunate that this masterful and spontaneously charged precursor of the *Study after Velázquez's Portrait of Pope Innocent X* has survived. While both setting and figure are sublimely resolved in the later Des Moines picture, the earlier and larger *Study after Velázquez* has a raw power and rare intensity centered about the screaming mouth. The earlier and previously undocumented *Study after Velázquez II*, while not aesthetically its equal, is nevertheless a wonderful discovery and of great art historical importance. The mouth and head of the figure are beautifully rendered, while the papal vestments are only briefly suggested in the now familiar starched white collar and hint of purple. In this pivotal picture, one can trace the transitional hanging curtain to the figure in the shower of *Painting*, 1950, while the red foreground shape in *Study after Velázquez* looks forward to the composition of the Sphinx pictures of 1953 and later.

Why did these paintings remain hidden for almost fifty years? One can only speculate that Bacon neither felt sufficiently confident to exhibit them at the time of their making

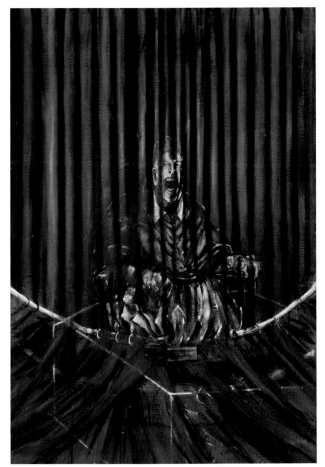

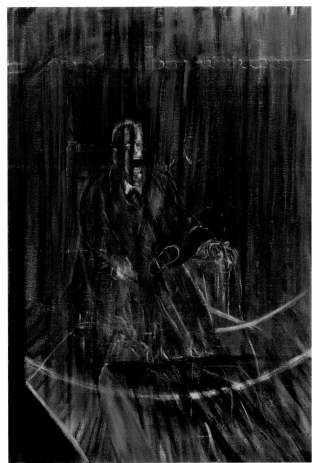

Study after Velázquez, 1950
Oil on canvas
78 x 54 inches
Courtesy The Estate of Francis Bacon/
Tony Shafrazi Gallery, New York

Study after Velázquez II, 1950
Oil on canvas
78 x 54 inches
Courtesy The Estate of Francis Bacon/
Tony Shafrazi Gallery, New York

nor felt the need to destroy them, as was the fate of so many other paintings early in his career. Perhaps he stored the paintings and forgot about them, or perhaps someone else was entrusted to dispose of them and could not bear to carry out the task. In 1950, before Bacon had pressing demands to produce pictures for the gallery exhibitions he enjoyed by 1953, it is easy to imagine that a less confident painter would be more self-critical in destroying and setting aside paintings.

The only nonpapal image included here is *Sphinx I*. In addition to sharing a similar formal composition, color palette, spare paint application, and enigmatic disposition,

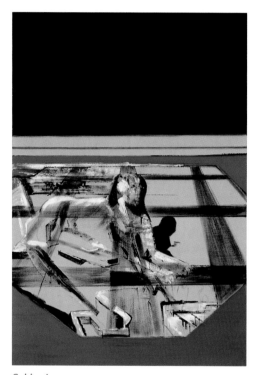

this masterful picture was made during the intensely creative summer of 1953 that produced its papal siblings. The sphinx as subject undoubtedly stems from the time Bacon spent in Egypt during a journey of 1950–51 to visit his mother in South Africa. He was greatly impressed by the antiquities he saw in Cairo and, some twenty years later, in expressing his admiration for Velázquez by comparing him to Cézanne, Bacon alluded to the power of Egyptian art:

I don't think Cézanne's people are very intense, his apples are more intense than his people, his apples are some of the greatest apples ever painted [laughing here]. His power of invention in forming an apple has never gone into his forming of human beings, he tends to make them inanimate objects, he doesn't extend his invention into the psyche of the human being. Yet if you look at Velázquez, his greatness is his interest in people. . . . Velázquez came to the human situation and made it grand and heroic and wasn't bombastic. He turned to a literal situation and made an image of it, both fact and image at the same time. The Pope [Pope Innocent X] is like Egyptian art; factual, powerfully formal and unlocks valves of sensation at all different levels.[8]

Sphinx I, 1953
Oil on canvas
77¼ x 53⅜ inches
Collection Carolyn P.
Farris, La Jolla,
California

While Ronald Alley in his important early monograph asserts that "the setting for the Sphinx paintings was derived from a photograph of the stadium prepared for the Nazis' Nuremberg rally,"[9] he neglects to point out significant similarities between this painting and a photograph of Bacon taken in 1928 in the park of the Schloss Nymphenburg at Munich.

These similarities include the vertical banding of both images, the massing of the crown in the sculpture to the head of the sphinx, the shape and quality of stone in the plinth to the base of the sphinx and, above all, the fortuitous echo of the shadow of a man holding a gun in the painting to the shadow cast by Bacon's hands on the plinth. To have blended several disparate photographic sources as contributing stimulants to picture making is entirely consistent with Bacon's mind and method.

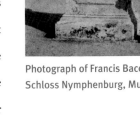

Photograph of Francis Bacon in park at Schloss Nymphenburg, Munich, 1928

Finally, Bacon always wanted his paintings to be mounted under glass and surrounded by traditional, heavy gold frames. In so doing, he sought the connection this drew to his painterly predecessors, the seriousness it brought to the endeavor and, above all, he reveled in the fortuitous reflection of the viewer superimposed in the painting, as each of us becomes complicit with the painter as both protagonist and voyeur.

Hugh M. Davies

THE DAVID C. COPLEY DIRECTOR

Museum of Contemporary Art, San Diego

NOTES

1. David Sylvester, *Interviews with Francis Bacon, 1962–1979*, rev. ed. (Oxford: Thames and Hudson, 1980), 17.

2. Hugh M. Davies and Sally Yard, *Francis Bacon* (New York: Abbeville Press, 1986), 23.

3. Davies and Yard, 110.

4. Hugh M. Davies, *Francis Bacon: The Early and Middle Years, 1928–1958* (New York: Garland Publishing, Inc., 1978), 110.

5. Ronald Alley and John Rothenstein, *Francis Bacon* (London: Thames and Hudson, 1964), 72.

6. Sam Hunter, "Francis Bacon: An Acute Sense of Impasse," *Art Digest* 28 (October 15, 1953), 16.

7. Alley and Rothenstein, 266.

8. Davies, 99.

9. Alley and Rothenstein, 75.

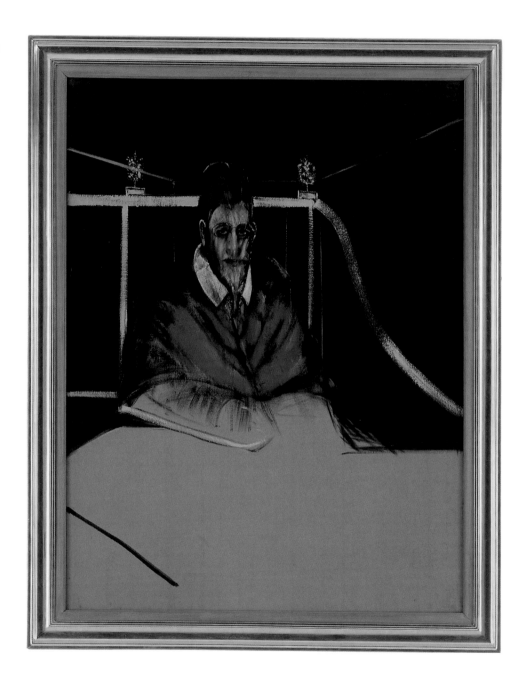

Study for Portrait I

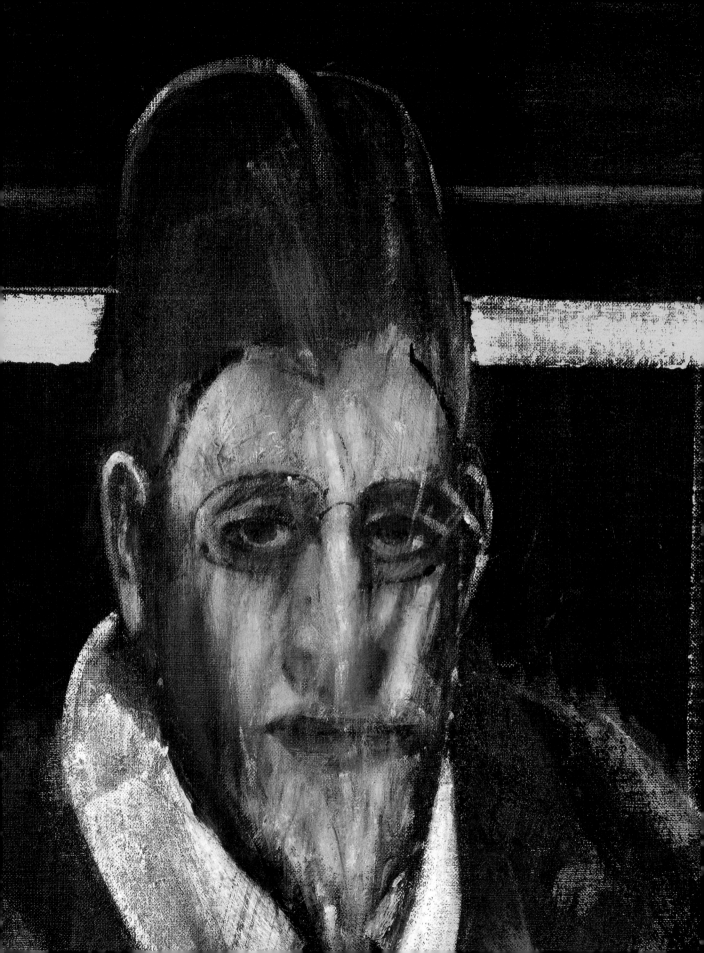

Polaroid of Francis Bacon
taken by Hugh Davies, London, 1973

Polaroid of Hugh Davies
taken by Francis Bacon, London, 1973

Hugh M. Davies

AUGUST 13, 1973

Reece Mews, South Kensington, London

FRANCIS BACON OK, Hugh, well listen, ask me everything that you want to know. What do you want to know? It is not the story of my life you want to know, it's the story of what?

HUGH M. DAVIES Well, one thing I was wondering about was the question of cultivated chance in your work.

FB Yes.

HMD The more you practice, the more you get—in terms of tennis—into the groove of the swing, the easier it is to have chance working for you. In other words, you cut down the odds. I wonder if you agree with the idea of cutting down the odds? In other words, your housecleaner could throw paint and have it land in the right place, but the fact that you've done it so many times before, you have what you could call an innate ability to throw it, or to know where you want it to go. So, the chances of your having the paint land in the right place are heightened by that practice and that experience and that instinct.

FB Well, of course it's heightened by the time that you've taken to do it, but nevertheless a marvelous accident may nevertheless happen in between your will and your involuntary action.

HMD Yes, but if you think of it in terms of archery, it would be possible that I could take one arrow and hit the bull's-eye the first time. However, somebody who's done a lot of archery is much more likely to get a bull's-eye the first time.

FB But then I don't know where the bull's-eye is. These things happen and then, of course, I manipulate them afterwards. I live my life between fact and chance.

HMD You say you don't know where the bull's-eye is, but you must have some idea of how you would like the thing to turn out. I mean, obviously afterwards you assess it to some extent and say, well, for instance, in the recent triptych where the white whip line goes along the shoulder . . .

FB I don't know. I don't know what I want. I just hope that luck will work extravagantly for me. After all, I've lived my whole life on luck and—from everything, not only from my personal life but from my life as a so-called artist—I've lived entirely on chance, hoping what is called "the chance" will always work for me.

HMD Yes, well, do you think as your life has progressed, and as you've cultivated this chasing of chance, that you've had chance working for you more and more?

FB I think I've become more aware of where chance might work for me, but as my whole life is bound up—can I say it in this way—I live a life bound up with nonsense in which I'm trying to do something, and from time to time luck intervenes on my side. And so often it doesn't, but from time to time it intervenes on my side.

HMD And you cannot anticipate when it will work for you?

FB Of course I can't. How could I? How can I?

HMD But there must be good days and bad days. And the bad days, when you don't even bother to begin, and the good days when, for some reason, things work.

FB The good days are the days when everything—luck, instinct, what is given to you by your instinct—works for you.

HMD But you can't anticipate which will be the good days?

FB No, never.

HMD Do you ever have the feeling when you wake up, "I'm going to be able to paint today?"

FB Not at all, never. I work every day practically, but I don't know the days when luck is going to work for me, and luck is what I call chance. I think we've called it by other names before—such as accident. When do I know if those will work for me? I never know. I don't wake up any day thinking that. I just start to work, and I just hope that accident, instinct, chance, everything, will work for me. I expect it to of course—hour by hour, day by day.

HMD Did you work today?

FB Didn't work today, no.

HMD Is it a month-to-month or a day-to-day thing when you are able to work?

FB No, it's absolute day to day, and I live my life day to day, hour by hour, minute by minute. I never expect to exist more than one minute from another, and so I hope—as I hope to exist from hour to hour—I hope every moment that chance will bring up the marvelous accident that I need.

HMD Looking at the work of the last five or six or ten years, there's an upward curve towards greater and greater success, and that must mean that chance can be cultivated. It isn't random like a roulette wheel.

FB You can't cultivate it, you see. I'm vain enough to think that my own brilliance cultivates chance. I'm vain enough to talk about my own brilliance. You can quote here or there, but of course I think that I cultivate accident. I cultivate chance, I cultivate, I try to cut away from myself what is called ideas of wanting, and out of not wanting, the appearance begins to emerge out of, out of, well, only out of chance, of course.

HMD Yes, I also thought about the days when nothing has gone right at all and you just start putting what could be called unconscious marks. You start putting paint down and not knowing what will happen. And occasionally out of that, the image that you want, the fact that you want, will appear, and you can work with that. How long does it take, is it a moment or so?

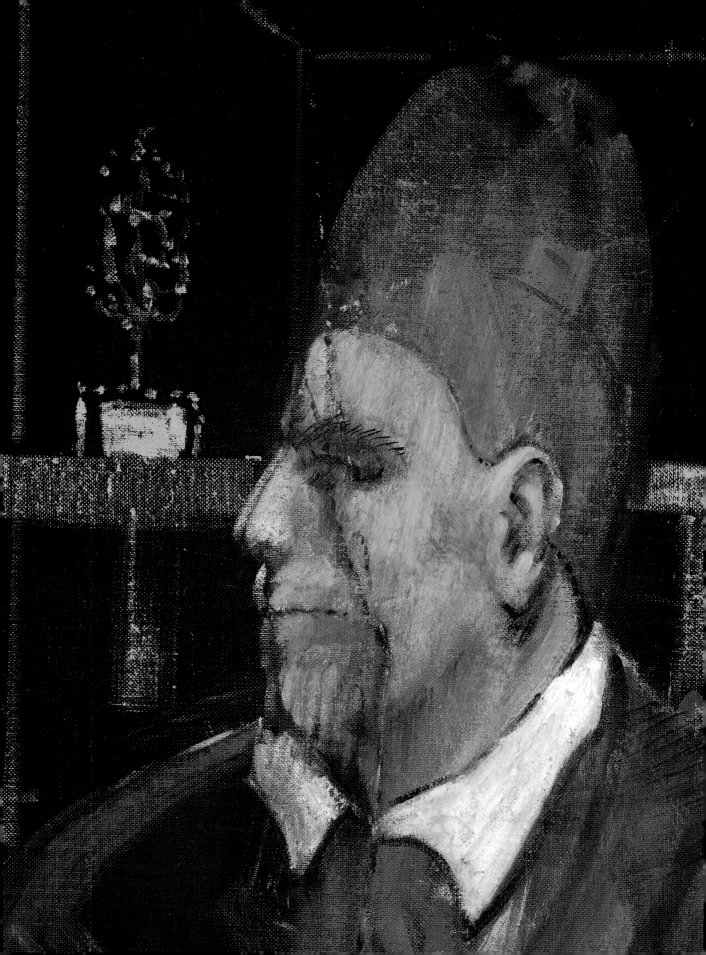

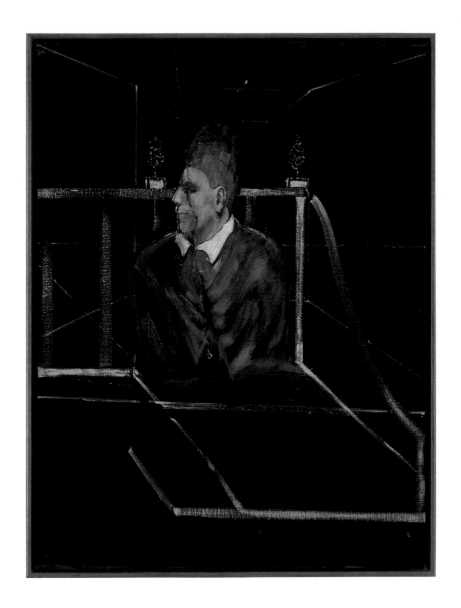

Study for Portrait II

FB It's only a moment or two, but of course it happens that way. But then, of course, you see I'm vain enough to think that I am brilliantly aware of everything that is offered me.

HMD A lot of people say creativity comes out of the struggle to create. Do you think that is true?

FB I would hate to put it in that exaggerated way. I think all one's got to accept is if you're an artist, your life is despairing and luck may work for you from time to time, and that's all I would say.

HMD Another thing you said, when you look at a portrait by Velázquez, you think that the painting is more about the artist than the sitter.

FB There always is, there always has been. If you look at a Velázquez, what do you think about? If you think about Rembrandt, I don't think about his sitters, I think about him. I think about Rembrandt, I think about Velázquez, I think people believe that they're painting other people, but they paint out their own instincts.

HMD They are really all self-portraits in a way.

FB In a curious way, in a curious way they always are.

HMD The people you generally paint are the ones that you've known for a long time, so that, as you say, when you use the photograph, you use it only as you would use a dictionary to re-remind yourself.

FB Exactly, then what am I painting—I'm painting the variations upon contours and form which are my own instinctive variations about contour and form. Not about them, can you see what I mean? But they, what I call, start me.

HMD They trigger your reactions, knowing the subjects as well as you do and knowing the contours of their faces.

FB Are there any questions I can answer? One can never answer a question clearly, but, what is called, drift around it. Is there anything you especially wanted to ask me?

HMD Surprising as it is, my feeling is that you appreciate Duchamp, not for his work, but for this idea of creating a modern myth. But what I'm not sure about is whether you appreciate just his intellectual efforts in creating this myth, or whether you appreciate the objects other than the figurative things.

FB No, certain paintings of his, like the *Big Glass*, I appreciate enormously.

HMD Aesthetically?

FB Aesthetically, it's true to say I've never seen it. I've seen Richard Hamilton's reproduction of it, and I've seen a number of photographs of it, and, listen, what does man do today? What is interesting, he is obsessed by. If you take figuration, he's interested in figuration, but it has no, it has no myth behind it. It's a fact and the only thing you can do in figuration—or I don't say, the only thing you can do, but the only interesting thing about figuration—is how far you can make it figurative and leave, make an image which is more profound than figuration. Because after all, who cares actually whether somebody dies, lives and dies, but what is interesting is, can you make a great image of this person that you're trying to portray? After all, that's one of the great and very strange things, and it's a curious way of, it's a curious dichotomy really. Why were the Egyptians able not only apparently to make appearance but leave great images as well?

HMD Yes, I was just looking at a new head that David Sylvester has. A beautiful Egyptian head in sculpted stone, and we were talking about that same thing. An anonymous craftsman, and yet all the focus of that civilization, the idea of gods and the possibility of immortality of humans and the sacredness of certain animals—all these things go into it.

FB But then we don't have that today. We have nothing at all, but can you make of a head an image? An image which unlocks the valves of sensation deeper than the appearance? Of course, I'm drunk today and I don't talk very clearly.

HMD I wanted to ask you more about *Las Meninas*, because I think in some way it helps to understand your art, to know about your reactions to other artists.

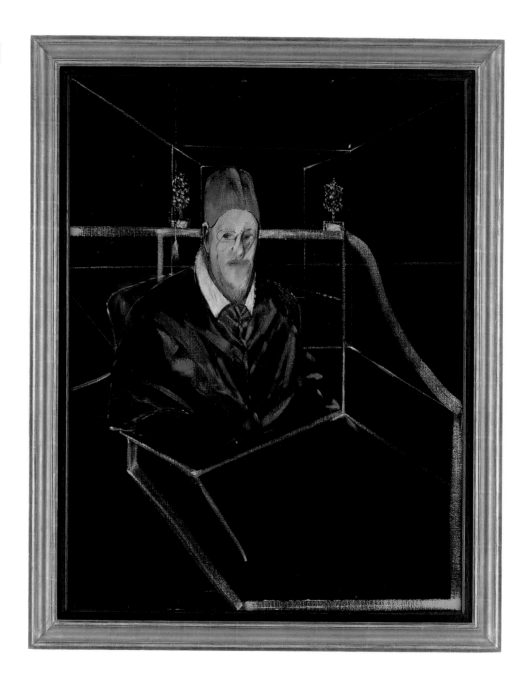

Study for Portrait III

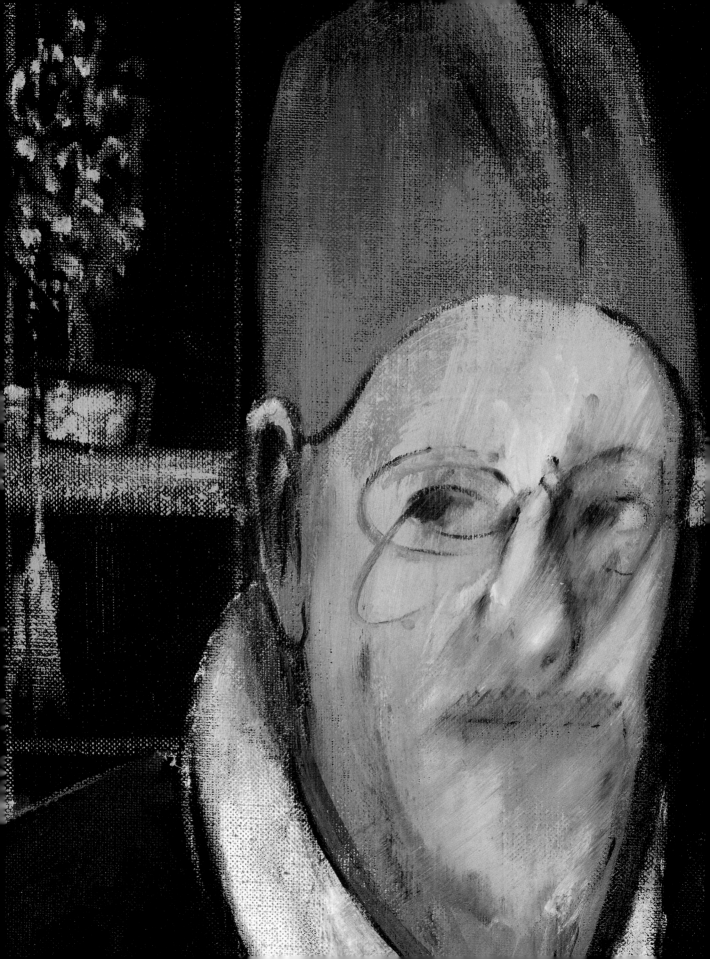

FB Well, if you think about a thing like *Las Meninas*, I think it's the greatest painting that's ever been made, because I think it probably . . . we don't know what those people looked like, but I think it came nearer to fantasy and imagery more than anything probably ever did. I think Velázquez was very, very extraordinary because if you analyze the heads of Philip IV and people like that, you will see that these are profound distortions. But they are distortions which distort themselves into fact. And that's why I think it's one of the greatest paintings that has ever been made, because I think, do you see, I think if you want to convey fact and if you have to do it, then this can only ever be done through a form of distortion. You must distort, if you can, what is called appearance into image.

HMD I have heard you paraphrase van Gogh, that "I want to lie, but I want to lie so that it's more truthful in the end."

FB All art is that, after all. All art is a lie. But how can I make it as real as possible?

Van Gogh, what is called, deformed appearance all the time to make it more real, and it's a thing that we hardly really understand. After all, if you think about Cubism, Cubism really was a decoration on Cézanne and it wasn't—it was really a decorative thing, it was a decorative occupation, finally. Everybody loves Cubism, we know. What I say will be thought of as being the most terrible thing, but in fact, much as I like a lot of Cubism, it was in fact a decoration on Cézanne. They took—and, after all, we're in a very hopeless period at this moment—but the thing is, if you want to make a portrait of somebody, how are you going to deform the image so profoundly and return it to fact?

And what else can I say? You see, Cézanne and van Gogh did find this curious way of putting the paint on in slabs all over, if you remember the way he put the paint on, and of course it was a rather miraculous invention. I'm sure it was an invention, made out of his instinct that he believed made the thing more real. And it did in fact, of course, because you're not only aware of that appearance but you're aware of the fact, you're aware of the stuff which it was made of. It's a very odd thing because you're aware of two things, you're aware of the fact that this is an artificial thing which is making a reality.

HMD For instance, I know you prefer the oil sketches of Seurat to his finished works like the *Grande Jatte*. Do you think that in trying to make it more monumental and more polished, he sacrificed more than he gained?

FB Well, it's a very complicated thing with Seurat. I prefer the sketches. On the other hand, of course, the final things were tremendously grand, and he made two different things. He didn't give you the instinctive drive of the sketches, but he did make marvelous monumental paintings out of his sketches or out of his ideas. Seurat is a very, very difficult problem to talk about. Which do you want? Do you want things which nobody can ever—do you want grandeur, or do you want instinctive, the pulse of an instinct beating in you?

HMD Well, ideally, I assume you'd want both.

FB You'd like to have both, but you see, in his big paintings, he had to, what is called, sacrifice the pulse of instinct for the grand design.

HMD Is Velázquez an example of somebody who has managed to combine the instinctual with the grand?

FB I think the thing about *Las Meninas*, I think it's one of the most extraordinary paintings probably that's ever been made, and I think there, he was able to combine one in an odd way with the other. But, of course, it's a very, very rare thing ever to happen.

HMD Did Velázquez work from sketches?

FB I don't know enough about it to know. I think he worked from the people who were before him.

HMD Directly on the full-size canvas?

FB I don't know enough—I mean, that would be fake to say that I knew. You know I never read a lot about other artists, although I've looked at them a great deal. But I don't know actually their ways of working. In my own life, of course, I would have loved to be grand and instinctive.

HMD As I see it, the progress in your career has been initially from the grand to the instinctual.

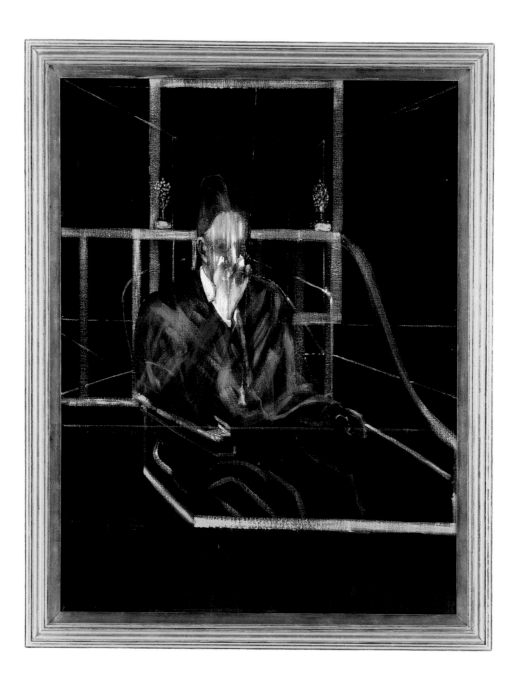

Study for Portrait IV

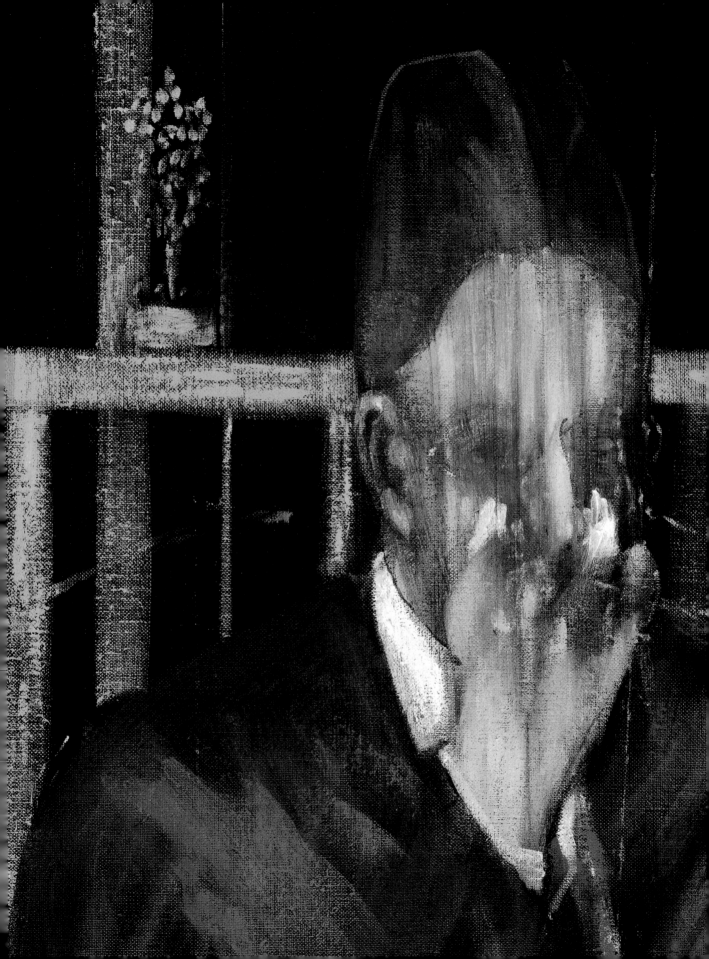

FB Like in my own life, I hope to be grandly instinctive. I don't think you capture the grandeur. The grandeur of form is a really instinctive thing, after all. What have I looked at all my life? I've looked at Egyptian things. I've looked at the great Greek things. I've looked at those things—it's not to do—and they have involved me profoundly as I've been involved with many poets and people I've been involved by—it's true to say only in translation—some of Aeschylus and translations of Sophocles and things like that. I've often been very involved by Shakespeare and things like that. I've been terribly involved by, with, a man like Eliot who I think had the most marvelous kind of sense—perhaps not on that scale—but a most marvelous sense of imagery. And so, in many ways, very often poets have, could I say, fortified me more than painters. They excite me more. Sometimes, I've often thought, I wish I could be a poet rather than a painter. But I can't, and there it is.

HMD Have you ever tried?

FB I've never tried, and I know I couldn't, as I haven't got that thing at all. I just—everything I think of goes into images.

HMD Do you think you may have retained your visual sense since you never had a formal education?

FB Well, I don't know, I don't know, Hugh. The thing about me is my whole sense is visual sense, really, my whole sensibility is a visual one.

HMD Another question I had for you is, at the beginning of your career, why did you start designing furniture?

FB I didn't know what else to do. I tried to earn a living when I was very young, and I tried to design furniture which, after all, which were just copies really of the modern furniture of the period.

HMD You've said that before, and I've looked at French furniture of that time, and I've looked at German work from the Bauhaus of that time, and I think you're running yourself down in saying that your furniture are copies, because I don't think they are. They have something that transcends copying by far.

FB I feel what I tried to do, really, was totally influenced by Corbusier.

HMD Yes, as a matter of fact, the *chaise longue* of Corbusier is one of the things that comes closest to your table using the chrome.

FB Yes, I think I was influenced by those people, and there it is.

HMD Did you ever know Corbusier?

FB No, I didn't, but I think that's what I was influenced by, and what I liked in those days. I don't know that I like them any longer, but that's another story.

HMD Do you like your own furniture?

FB No, I loathe it, of course. I loathe my own furniture. I think it's absolutely horrible.

HMD I don't agree. I think the table, the circular table, is a beautiful piece. I haven't seen the actual piece—I've only seen photographs—but I think the combination of clear glass and mirror for the circular top is quite inspired.

Mentioning Corbusier, how do you react to modern architecture? Are there any architects that you like more than others?

FB I expect there are, I believe there are Italians who are much better, but I don't really know what they've done, do you know what I mean? Because I don't know, you've got to see them and I haven't been enough in Italy to see the things they've done. I believe they are the best, really. I don't really know. We have nobody in this country at all, I might tell you. There's been no architecture in this country. This is a very peculiar country. It's a kind of, it's always terribly backward in a peculiar way, this country, and there have been no architects like there have been, really, no painters.

HMD It's backward visually, but not in terms of literature.

FB In literature, it's always had a long tradition and the tradition has always been very strong in literature, but not visually.

HMD I have often thought that Shakespeare's influence has made this such a literary country and that's why the visual side hasn't been developed.

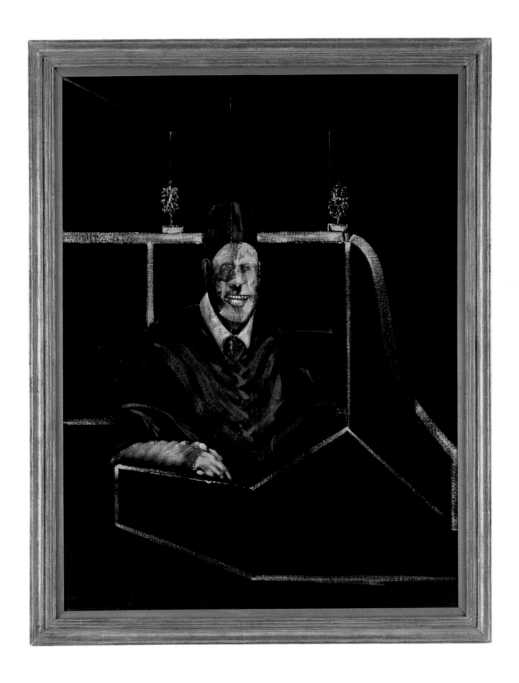

Study for Portrait V

FB I don't think it's because of Shakespeare. I think you had a phenomena that came up at that moment, whoever Shakespeare was, and wrote these extraordinary things. But then, don't forget, you had a collection of people at that time who were phenomenally gifted. We've had nothing since and there's never been, I mean there have been a few painters who've turned up, like Turner and Constable, and you might say Reynolds and people like that. I think the most extraordinary of them all—although Turner is in a way the most exaggerated—I think the greatest, in a way, was Constable, but it's not been a country of visual artists.

HMD It hasn't, has it? Very strange.

Another thing I want to ask you is whether you are a descendant of the Elizabethan Francis Bacon?

FB I've never gone into whether in fact I am a descendant of Francis Bacon or not. I'm called Francis Bacon. Whether I'm really a descendant . . . he had no children, he was a homosexual as you know, and I don't know whether his brothers perhaps had children, or whether I really come from that family or not. I don't really even know to this day. It would take a terribly long time to go through the whole history of the thing, and I've never really bothered to go through . . . I've never gone to Somerset House where you can trace your ancestry, but I've never bothered to do it. Many people have said to me, why do you never do it? And I've never bothered to, because it would take so long, because it doesn't really mean anything to me. Although I think he was an extraordinary man—that's another story—it doesn't matter to me one way or the other whether he's a relation of mine.

HMD I didn't really mean just in terms of tracking down whether he actually was or not, but the fact that you have the same name must have piqued your curiosity about this man.

FB No, I was given that name, but I've never plotted it out as to whether I've even come from the same family. I don't know. And, oddly enough, I could take the trouble to go to—you have to go to the College of Heralds in fact, because my father had the kind of seal printed on his plates and everything like that. . . . What I am trying to say—I think it's possible because my father had two letters from Francis Bacon, and as he was a gambler and

needed money, he sold them to the Duke of Portland, for quite a lot of money in those days, to pay some of his gambling debts. So it is quite possible if he had these letters of Francis Bacon that we do come from the same family. But then, of course, he had no children. Francis Bacon was queer, and as you see in *Elizabeth and Essex* and everything else, but of course, Lytton Strachey probably wasn't correct about those things. But whatever "queer" means, he preferred men to women. There you are. He had no children, so I would be, if I was related to him, I would be "collateral descendant."

HMD I wonder by the way you said "queer," do you resent that term?

FB I don't resent it at all. It's just a way of putting it—homosexual, shall I say. I don't resent it at all. I'm just using an old-fashioned expression. I don't think it means anything any longer.

HMD But it has meant something.

FB It meant something, you see. It began to mean things through the Victorian era. I don't think it meant anything in Regency times, it just became a certain kind of moral thing that happened during the reign of Queen Victoria. Not her early reign, but the late part of her reign, I think, when the church really took over.

HMD People always talk about what century would you like to live in most. If you could choose a century to live in, would you prefer to live in one other than this?

FB No, I'd live today. There's no century I want to live in. After all, I'm accustomed to today. There's nothing else I want to live in.

HMD You wouldn't want to go back to Egyptian times or Greek times?

FB No, no. I mean, where would I be born? Where would I be thrown up? I'm terribly pleased to be thrown up, as I was in this particular type of society, and ghastly as it may be, but there I was, and I've made what I can of it.

HMD I would prefer to have lived from about 1900. I think from 1900 to 1935 was a much more interesting time in terms of all the discoveries that were made in every field. In art, the ramifications of Cézanne; in science, Einstein. It's almost as if we've been freewheeling since the beginning of the century, trying to work out what was actually discovered then.

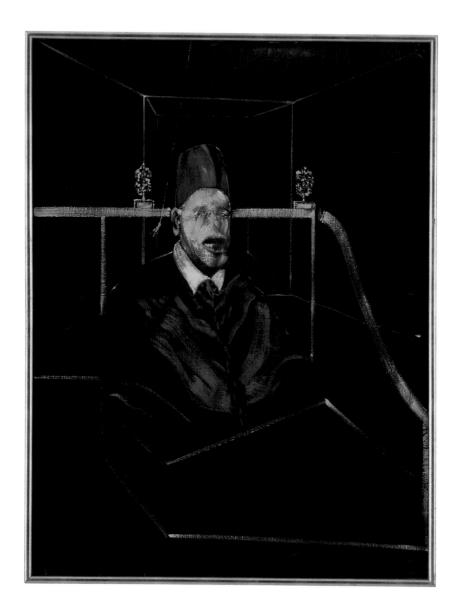

Study for Portrait VI

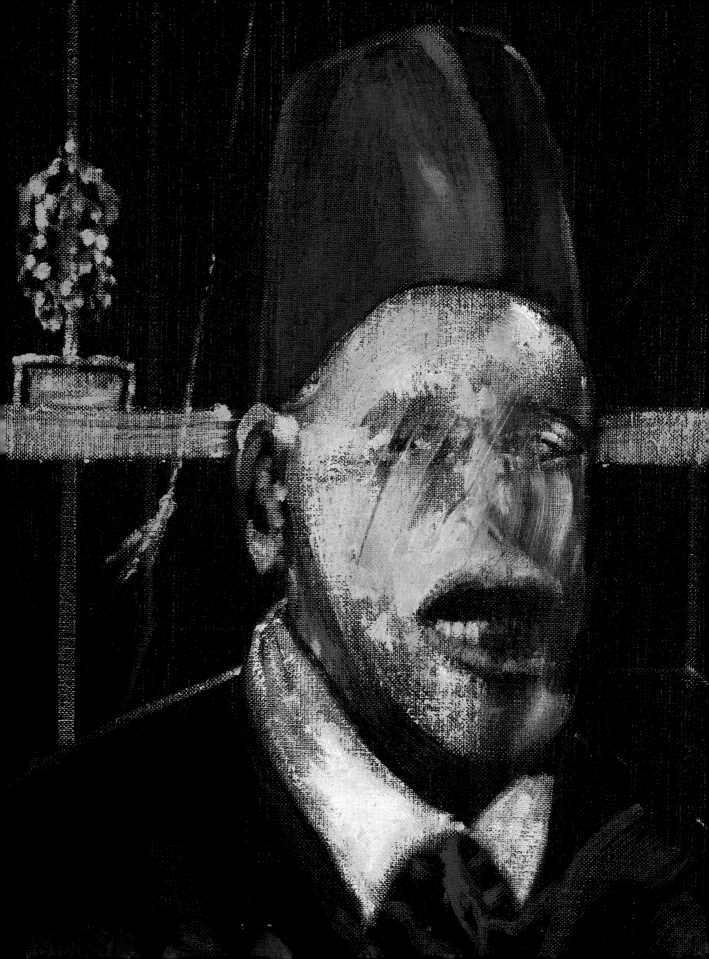

FB But then, see, Hugh, I'm vain enough to say that I reinvent—and this is a really vain thing to say—I think I've reinvented methods by which appearance and things can be made, and so therefore I don't think like that. After all, I've known what the Cubists were like, I've known what Cézanne was like, I've known what the Impressionists were like—who I think are terrific. But through knowing all about them, they've given me the opportunity to reinvent something myself.

HMD Do you think it's sort of a chain of discovery?

FB It's always a chain. You see, most art has gone out into abstraction, and I think abstraction is an evasion of the problem. Because the problem, I believe, always is the problem of appearance, and how can I reinvent the ways of remaking appearance?

HMD I think you're absolutely right. I think in a hundred years, people may well look back at abstraction and think that it was an interesting off-shoot that turned out to be a cul-de-sac.

FB You see, when I talk like this, it sounds like a terrible vanity. But, you see, I think I'm much more—it's a ridiculous word to use—I think I'm much more modern than any abstractionists can be. Only because I think I'm trying to reinvent how appearance can be made.

HMD Yes, I think you're right, but in terms of an alternative abstraction, what do you think of Pop art or Hyper-Realism?

FB Well, listen, there are many things. I like Pop art, but do you want appearance made so simply? Do you want appearance made as simply as Hyper-Realism? Do you not think that images should be made which unlock the valves of sensation? As appearance and as fact.

HMD Do you see the pendulum swinging back toward figuration from abstraction?

FB Well, shall I tell you this—that if it comes back, it will come back to another thing outside fashion. It will come back to people who can find a way of reinventing ways by which appearance can be made.

HMD Why have you never deviated from making figurative art?

FB Why should I deviate? Because I don't believe in the other things. I only stick to what I believe in. After all, I have my instinct. After all, I live by my instinct and not by my fashion.

HMD I believe that over the next fifty years your commitment to figuration will be completely vindicated.

FB Well, *on vera*, we'll see. Life goes round, whether it happens or not. But I couldn't do anything else. I mean, I'm not doing this out of any form of trying to be grand—or I can't think of the word now—out of any kind of ideological thing, because I think it's the only way it can go. Because I think, what does man want from generation to generation? Reinvent the ways that appearance can be made, and be brought back onto his nervous system more violently than what's been made before, because what's been made before is already become an absorbed solution. So they need to, every generation needs to, reinvent appearance.

HMD It's probably easier to paint rather than talk about it.

FB It's very hard to talk about painting. It's one of the most difficult things. You can't ever really talk about painting, because it's another medium. You're always talking, really, about painting on the sides, because you can't really talk about painting. This is the misfortune about it, because if you could, I mean, as somebody once said, "If I could talk about it, I wouldn't." I think some dancer once said, I think it was Pavlova, said "If I could talk it, I wouldn't dance it." I have nothing mixed up. I'm an independent judge of despair, which I know that life is, from birth to death.

HMD When I see your work, I often think of that phrase from Eliot—something like, "everything is birth, copulation, and death—that's all there is."

FB Well, you watch, after all, from what you can call maturity, fifteen or sixteen. You watch a long declining line towards the grave.

Study for Portrait VII

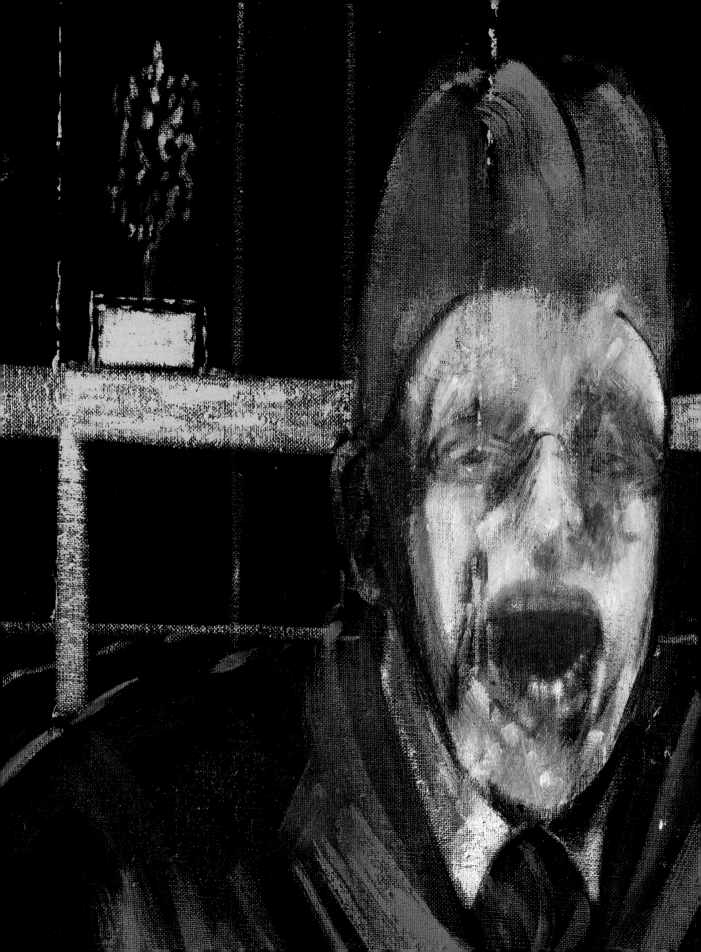

HMD You once explained that the Egyptians had some idea of myth and even for Velázquez and Rembrandt there were still some religious possibilities, and today all that's been stamped out. Would you say that your art is the product of a demythological age?

FB Totally demythified. And you see, after all, I don't say it's a good thing, because when you think of some of the great things of Egyptian art—there were things that they put in the graves with the people, with the dead, and it was marvelous because it was something to, as it were, comfort them in their journey to the next world, or to comfort them in the next world. Like they even gave them food. And if they didn't, it's a very complicated thing with the Egyptians how much they knew or thought, because, after all, they didn't give them food sometimes. They just painted the food on the wall, you see. And that's a very odd thing about them. What they thought or what they really believed is another interesting thing. But then, we who believe in nothing, we make only our myths out of our existence and it's, of course, a nuisance.

I used to use the crucifixion, not because I believed in it, but as a myth on which I felt many things. But I would never use it or could never use it again because it's become—it was always dried up for me, but it's become impractical to even use it. Now I realize I could make a thousand ways of what is called elevating the body or putting it where it has nothing to do with anything.

Listen, we live, how are we going to make our body, our experience between birth and death, into an image? There are no myths to give it, there's nothing to give it, there's just the fact. Now, do you make it or don't you? You can carry on, of course, like Henry Moore, who makes big kind of semi-abstract stuff, but then I don't think that's an answer.

HMD Yes, well, that's the same as the Rubens false "grand manner." You might say it's a false grand humanism.

FB Well, of course it's about nothing. It's about, it's a false idea about, it's a kind of false humanity.

HMD What do you find optimistic about this situation of a demythological society? Is there anything optimistic about it?

FB I don't think it's become optimistic because it's demythologized. I think that your very existence between birth and death is optimistic. The fact that here you are, you've come here, you've been made, you've been created. And what are you going to do with it? Commit suicide or carry on?

HMD Yes, well, if you carry on, you're an optimist, right?

FB Well, this is a problem. Are you? I wouldn't say that I was an optimist, and yet I love life, even though I know it's ebbing from me rapidly.

HMD You do love life?

FB Of course. After all, I've got nothing else to like. I don't know anything else but life, so what else have I got to like but life?

HMD Are you curious as to what happens when you die?

FB I know I'm just dead. I know I just become a skeleton. I just go back to the earth.

HMD But nobody knows. Nobody knows what happens.

FB Of course we do. We all know. That's all there is. We become once again the compost of the earth. That's all there is.

HMD It would seem that the more they learn about how the brain works, that it's all based on chemistry and these chemicals break down just the way flesh breaks down.

FB Of course, there's nothing else about life. We're here for a moment, and then we pass back into the earth. We didn't come from the earth—it's true to say—we came from the conjugation of our mother and our father's sperm. But they came from that. We just go back to the earth. After all, the whole world is a vast lump of compost.

HMD Yes, but don't you think there's any rationale or reason for this compost? Any purpose?

FB No, none at all.

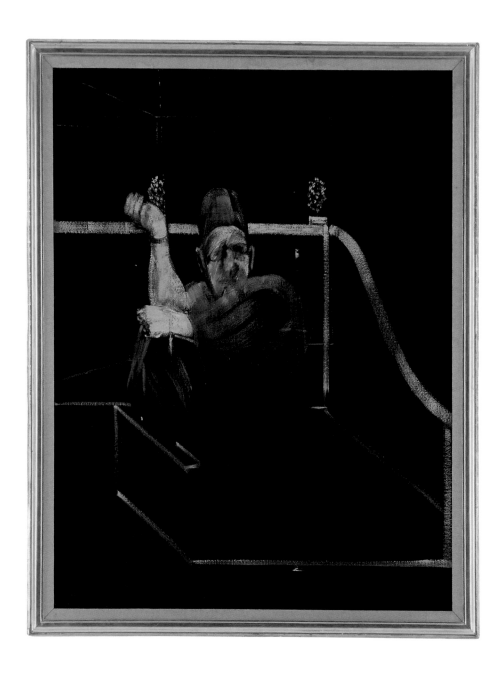

Study for Portrait VIII

HMD Then why does it happen? Is it just another existential state?

FB There's no reason for it.

HMD Well, do you think there's any progress?

FB No, I think man makes progress. I think man makes it out of his inventions and that kind of thing, but there's nothing else. He may even be brilliant enough to make what is called life much longer, or something like that. He even may make immortal life, but it will only be a man-made immortality. I have no belief in anything whatsoever. I think I'm here, and of course, either I would be a pessimist and say it's too awful . . . it's not that, it's just there I am, it's a fact, I was born. My mother, my father, there it was—the copulation, and I'm the result of it and I exist in that way as a thing. Thing. Of course, I want to be the most brilliant thing that I can be (chuckle).

HMD But still, it's just fleeting, just a crystallization of your existence?

FB Yes, of course.

HMD Well, how about the idea that your, whatever you want to call it, will live on in your work? That you can achieve immortality through art and that sort of thing?

FB Well, it's not immortality. That's a thing we absolutely don't know about. I always think artists are so ridiculous to believe that this will go on. Some have, and some haven't. I mean whether people will think about my work in a hundred years' time, I won't be here to know, and I shall never know, so there it is. I shall never know, so therefore it cuts out in a way from my attitude to life vanity. Because I don't really care, because I don't know if it will be any good or not.

HMD And you never will know.

FB And I shall never know.

HMD Yes, that's the ironic twist, isn't it?

FB See, I shall never know.

Study after Velázquez's Portrait of Pope Innocent X,
1953
Oil on canvas
60¼ × 46½ inches
Nathan Emory Coffin Collection of the Des Moines
Art Center; Purchased with funds from the Coffin
Fine Arts Trust

Study for Portrait I, 1953
Oil on canvas
59⅞ × 46½ inches
Collection Denise and Andrew Saul, New York

Study for Portrait II, 1953
Oil on canvas
60½ × 45½ inches
Private collection

Study for Portrait III, 1953
Oil on canvas
60 × 45⅞ inches
Private collection; Courtesy Alex Reid & Lefevre
Ltd., London

Study for Portrait IV, 1953
Oil on canvas
60 × 45¾ inches
Collection Frances Lehman Loeb Art Center,
Vassar College, Poughkeepsie, New York, Gift of
Mrs. John D. Rockefeller 3rd (Blanchette Hooker,
Class of 1931)

Study for Portrait V (Cardinal V), 1953
Oil on canvas
60⅛ × 46⅛ inches
Collection Hirshhorn Museum and Sculpture
Garden, Smithsonian Institution, Gift of Joseph H.
Hirshhorn Foundation, 1966

Study for Portrait VI, 1953
Oil on canvas
60 × 45¾ inches
Collection The Minneapolis Institute of Arts,
The Miscellaneous Works of Art Fund

*Study for Portrait VII (Number VII from Eight
Studies for a Portrait),* 1953
Oil on linen
60 × 46⅛ inches
Collection The Museum of Modern Art, New
York, Gift of Mr. and Mrs. William A. M. Burden,
1956

Study for Portrait VIII, 1953
Oil on canvas
60 × 46 inches
Private collection

Sphinx I, 1953
Oil on canvas
77¼ × 53⅜ inches
Collection Carolyn P. Farris, La Jolla, California

Study after Velázquez, 1950
Oil on canvas
78 × 54 inches
Courtesy The Estate of Francis Bacon/
Tony Shafrazi Gallery, New York

Study after Velázquez II, 1950
Oil on canvas
78 × 54 inches
Courtesy The Estate of Francis Bacon/
Tony Shafrazi Gallery, New York

1909
October 28—born at 63 Lower Baggot Street, Dublin, Ireland, to English parents, Edward and Winifred Bacon. He is perhaps a collateral descendant of Francis Bacon, the philosopher.

1914
The Bacon family moves to London, initiating a succession of shifts between England and Ireland.

1925
Bacon moves to London with a small allowance from his family; works for a few months in an office.

1927–28
Spends two months in Berlin, then travels to Paris, where he works now and then as an interior decorator. A Picasso exhibition at the Paul Rosenberg Gallery prompts him to consider becoming an artist, and he makes his first drawings and watercolors.

1929
Returns to London and sets up a studio at 7 Queensberry Mews, where he presents an exhibition of furniture and rugs that he designed. Begins to paint in oils.

1930
Exhibits his paintings and furniture together with paintings by Roy de Maistre in the Queensberry Mews studio.

1931
Moves to Fulham Road.

1933
Herbert Read reproduces *Crucifixion* (1933) in his book *Art Now*. Bacon moves to 71 Royal Hospital Road at about this time.

1934
February—installs an exhibition of his paintings at the Transition Gallery, Sunderland House. Spends less time painting.

1936
The work that he submits to the *International Surrealist Exhibition* in London is rejected as "insufficiently surreal." Moves to 1 Glebe Street around this time.

1937
January—four of his paintings are included in the exhibition *Young British Painters* at Thomas Agnew & Sons, London.

1941–44
Lives for a time in Petersfield, Hampshire. Returns to London and rents a studio at 7 Cromwell Place, where John Everett Millais had painted. Unsuited for military service because of asthma, Bacon works in the Civil Defense Corps rescue service. Destroys most of his early work.

1944
Resumes painting seriously. Introduces the theme of the Furies in *Three Studies for Figures at the Base of a Crucifixion*.

1945
April—two paintings included in a group exhibition at the Lefevre Gallery, London.

1946–50
Lives primarily in Monte Carlo, returning periodically to London. Develops a friendship with Graham Sutherland.

1948
Alfred H. Barr, Jr., buys *Painting* (1946) for The Museum of Modern Art, New York.

1949

Completes the series of six *Heads* initiated the previous year. November–December—these *Heads* are included in his first solo exhibition at the Hanover Gallery, London, organized by Erica Brausen, who becomes his agent (until 1958).

1950

Paints *Study after Velázquez* and *Study after Velázquez II*. Fall—teaches at the Royal College of Art, London, for a few weeks. Winter—sets off for several months in South Africa to see his mother; en route stops for a few days in Cairo.

1951

Completes first series of Popes.

1951–55

Moves several times within London.

1952

Spring—visits South Africa again.

1953

February—paints *Study after Velázquez's Portrait of Pope Innocent X*. Summer—*Study for Portraits I–VIII* series and *Sphinx I* completed. October–November—first solo exhibition held abroad, at Durlacher Brothers, New York.

1954

Chosen as one of three artists (along with Ben Nicholson and Lucian Freud) to represent Great Britain at the *XXVII Venice Biennale*.

1955

January 20—retrospective exhibition opens at the Institute of Contemporary Arts, London.

1956

Visits his friend Peter Lacey in Tangier, where he rents an apartment. Returns often to Tangier during the next three years.

1957

February 12—first solo exhibition in Paris opens at the Galerie Rive Droite. March–April—a series of paintings after van Gogh is shown at the Hanover Gallery.

1958

First solo exhibitions held in Italy. Signs a contract with Marlborough Fine Art Ltd., London.

1959

September–December—solo exhibition held as part of the *V Bienal de São Paulo*. Spends a few months in St. Ives, Cornwall.

1960

March–April—first solo exhibition held at Marlborough Fine Art Ltd., London.

1961

Fall—moves to Kensington.

1962

May–July—the Tate Gallery, London, presents a major retrospective exhibition, which in modified form travels to a number of European cities. Bacon uses the large triptych format for the first time since 1944, in *Three Studies for a Crucifixion*.

1963–64

October–January—the Solomon R. Guggenheim Museum, New York, shows his first American museum retrospective, which travels to the Art Institute of Chicago.

1964

Meets George Dyer, who appears in many of his paintings over the next decade and a half.

1967

Awarded the Painting Prize of the Pittsburgh International Series, Museum of Art, Carnegie Institute.

1968

Fall—visits New York for an exhibition of his recent paintings at Marlborough-Gerson Gallery.

1971

October 26—a major retrospective opens at the Grand Palais, Paris, which travels to the Städtische Kunsthalle, Düsseldorf. George Dyer dies in Paris.

1972–74

Paints the "black" triptychs influenced by Dyer's death.

1975

Spring—travels to New York for the opening of *Francis Bacon: Recent Paintings, 1968–1974* at the Metropolitan Museum of Art.

1983

Retrospective, organized by the National Museum of Modern Art, Tokyo, travels throughout Japan.

1985

Retrospective, organized by the Tate Gallery, travels to the Staatsgalerie, Stuttgart, and the Nationalgalerie, Berlin, 1986.

1989

Retrospective, organized by the Hirshhorn Museum and Sculpture Garden, Smithsonian Institution, Washington, D.C., travels to the Los Angeles County Museum of Art and The Museum of Modern Art, New York.

1992

April 28—dies while vacationing in Madrid.

INTERVIEWS AND STATEMENTS

Bacon, Francis. "Mathew Smith—A Painter's Tribute." In *Mathew Smith: Paintings from 1909–1952*, exhibition catalogue. London: Tate Gallery, 1953.

Gilder, Joshua. "I Think about Death Every Day." *Flash Art* 112 (May 1983): 17–21. Interview. Originally published in *Saturday Review* (September 1981): 36–39.

Peppiatt, Michael. "From a Conversation with Francis Bacon." *Cambridge Opinion* 37 (January 1964): 48–49.

Ritchie, Andrew Carnduff, ed. *The New Decade: 22 European Painters and Sculptors*, exhibition catalogue. New York: Museum of Modern Art, 1955. Includes statements.

Sylvester, David. *Francis Bacon Interviewed by David Sylvester*. New York: Pantheon, 1975. Published in England as *Interviews with Francis Bacon*. London: Thames and Hudson, 1975.

———. *Interviews with Francis Bacon, 1962–1979*. Rev. ed. Oxford: Thames and Hudson, 1980.

———. *The Brutality of Fact: Interviews with Francis Bacon*. 3rd ed. New York: Thames and Hudson, 1988.

MONOGRAPHS AND SOLO-EXHIBITION CATALOGUES

Ades, Dawn, and Andrew Forge. *Francis Bacon*, exhibition catalogue. London: Tate Gallery, 1985. Includes note on technique by Andrew Durham and extensive bibliography compiled by Krzysztof Cieszkowski.

Alley, Ronald, and John Rothenstein. *Francis Bacon*, exhibition catalogue. London: Tate Gallery, 1962.

———. *Francis Bacon*. London: Thames and Hudson, 1964. Catalogue raisonné and documentation.

Alloway, Lawrence. *Introduction to Francis Bacon*, exhibition catalogue. New York: Solomon R. Guggenheim Museum, 1963.

Alphen, Ernst van. *Francis Bacon and the Loss of Self*. London: Reaktion Books, 1992.

Davies, Hugh M. *Francis Bacon: The Early and Middle Years, 1928–1958*. New York: Garland Publishing, Inc., 1978. Reprint, Ph.D. dissertation, Princeton University, 1975. Includes extensive bibliography, 1978.

Davies, Hugh M., and Sally Yard. *Francis Bacon*. New York: Abbeville Press, 1986.

Farr, Dennis. *Francis Bacon: A Retrospective*, exhibition catalogue. New York: Harry N. Abrams; The Trust for Museum Exhibitions, 1999.

Farson, Daniel. *The Gilded Gutter Life of Francis Bacon*. London: Century, 1993.

Geldzahler, Henry. Introduction, *Francis Bacon: Recent Paintings, 1968–1974*, exhibition catalogue. New York: Metropolitan Museum of Art, 1975.

Gowing, Lawrence, and Sam Hunter. *Francis Bacon*, exhibition catalogue. Washington, D.C.: Hirshhorn Museum and Sculpture Garden, Smithsonian Institution; Thames and Hudson, 1989.

Leiris, Michel. *Francis Bacon: Full Face and in Profile*. London: Thames and Hudson, 1988.

Peppiatt, Michael. *Francis Bacon: Anatomy of an Enigma*. London: Weidenfeld & Nicolson, 1996.

Russell, John. *Francis Bacon*. Greenwich, Conn.: New York Graphic Society; London: Thames and Hudson, 1971. Rev. ed., New York: Oxford University Press; London: Thames and Hudson, 1979.

Sylvester, David. *Francis Bacon: The Human Body*, exhibition catalogue. London: Hayward Gallery, 1998.

—————. *Looking Back at Francis Bacon*. New York: Thames and Hudson, 2000.

SOLO EXHIBITIONS

Transition Gallery. *Francis Bacon*. London, 1934.

Hanover Gallery. *Francis Bacon*. London, 1949, 1950, 1951, 1952, 1954, 1956, 1957, 1958.

Beaux-Arts Gallery. *Francis Bacon: New Paintings*. London, 1953.

Durlacher Brothers. *Francis Bacon*. New York, 1953.

Institute of Contemporary Arts. *Paintings by Francis Bacon*. London, 1955.

Marlborough Fine Art Ltd. *Francis Bacon, Paintings, 1959–60*. London, 1960.

Nottingham University. *Francis Bacon*. Nottingham, England, 1961.

Tate Gallery. *Francis Bacon*. London, 1962. Traveled to Städtische Kunsthalle, Mannheim; Galleria Civica d'Arte Moderna, Turin; Kunsthaus Zurich; and Stedelijk Museum, Amsterdam.

Solomon R. Guggenheim Museum. *Francis Bacon*. New York, 1963. Traveled to the Art Institute of Chicago.

Hamburger Kunsthalle. *Francis Bacon*. Hamburg, 1965. Traveled to Moderna Museet, Stockholm; Museum of Modern Art, Dublin.

Galeries Nationales du Grand Palais. *Francis Bacon*. Paris, 1971. Traveled to Städtische Kunsthalle, Düsseldorf.

Metropolitan Museum of Art. *Francis Bacon: Recent Paintings 1968–1974*. New York, 1975.

National Museum of Modern Art. *Francis Bacon: Paintings, 1945–1982*. Tokyo, 1983. Traveled to Museum of Modern Art, Kyoto; Aichi Prefectural Art Gallery, Nagoya.

Tate Gallery. *Francis Bacon*. London, 1985. Traveled to Staatsgalerie, Stuttgart; Nationalgalerie, Berlin, 1986.

Hirshhorn Museum and Sculpture Garden, Smithsonian Institution. *Francis Bacon*. Washington, D.C., 1989. Traveled to Los Angeles County Museum of Art; The Museum of Modern Art, New York, 1990.

Museo d'Arte Moderna. *Francis Bacon*. Lugano, 1993.

XLV Biennale di Venezia, Museo Correr. *Figurabile Francis Bacon*. Venice, 1993.

Centre Georges Pompidou. *Francis Bacon*. Paris, 1996.

Tony Shafrazi Gallery. *Francis Bacon*. New York, 1998–99.

Museum of Contemporary Art, San Diego. *Francis Bacon: The Papal Portraits of 1953*. La Jolla, 1999.

SELECTED FILMS

Francis Bacon: Grand Palais. 1971. Directed by Gavin Miller. Produced by Colin Nears for BBC Television, London, in connection with the retrospective exhibition at the Grand Palais, Paris.

The Brutality of Fact. 1984. Interview with David Sylvester. Directed by Michael Blackwood. Produced by Alan Yentob. Made by BBC Television, London, for Arena.

Francis Bacon. 1985. Interview with Melvyn Bragg for the South Bank Show, London Weekend Television.

Love Is the Devil. 1998. Screenplay partly based on *The Gilded Gutter Life of Francis Bacon*, Daniel Farson. Directed by John Maybury. Coproduced by British Film Institute and BBC Films.

2001—2002

ADMINISTRATION

Hugh M. Davies, The David C. Copley Director

Charles E. Castle, Deputy Director

Trulette M. Clayes, CPA, Controller

Kathlene J. Gusel, Administrative Assistant

Michelle Johnson, Staff Accountant

Sonia Manoukian, Executive Assistant

Robin Ross, Accounting/Personnel Clerk

Marina Saucedo, Business Office Assistant*

CURATORIAL

Toby Kamps, Curator

Max Bensuaski, Assistant Preparator

Tamara Bloomberg, Research Assistant*

Gabrielle W. Bridgeford, Education Programs
 Assistant

Miki Garcia, Curatorial Intern

Gwendolyn Gómez, Community Outreach
 Coordinator

Mary Johnson, Registrar

Becky Judson, Registrarial Assistant

Doriot Lair, Curatorial Coordinator

Kelly McKinley, Education Curator

Ame Parsley, Preparator

Amy Schofield, Librarian*

Kim Schwenk, Curatorial Assistant

DEVELOPMENT

Anne Farrell, Director of Development and
 Special Projects

Jane Rice, 21st Century Campaign/Major Gifts
 Director

Kraig Cavanaugh, Data Entry Clerk*

Pamela Erskine-Loftus, Development/Travel
 Programs Coordinator

Veronica Lombrozo, Grants Officer

Synthia Malina, Development Manager

Regina Fianza Mary, Development/Membership
 Assistant

Tamara Wiley, Corporate Giving Officer

VISITOR SERVICES AND MARKETING

Jini Bernstein, Events and Visitor Services Manager

Jana Purdy, Marketing Manager*

Jon Burford, Event Manager

Laurie Chambliss, Public Relations/Marketing
 Assistant

Jennifer Morrissey, Public Relations Officer

Edie Nehls, Special Events Coordinator

Mike Scheer, Production Manager

Renee Yeh, Events Assistant

event managers*

RETAIL SERVICES

Jon Weatherman, Manager of Retail Services
Delphine Fitzgerald, Assistant Bookstore Manager
Carlos Guillen, Assistant Bookstore Manager
Michelle Thomas de Mercado, Assistant Bookstore
 Manager*
bookstore clerks*

FACILITIES AND SECURITY

Drei Kiel, Museum Manager
Mariela Alvarez, Receptionist (MCA Downtown)*
Shawn Fitzgerald, MCA Downtown Site Manager
Tauno Hannula, Facilities Assistant
David Lowry, Chief of Security
Ken Maloney, Museum Attendant
Javier Martinez, Assistant Chief of Security
James Patocka, Facilities Assistant
Nicholas Ricciardi, Receptionist (La Jolla)
Demitrio Rubalcabo, Museum Attendant,
 MCA Downtown
Mario Torres, Facilities Assistant*
museum attendants*

*Part-time

The exhibition *Francis Bacon: The Papal Portraits of 1953*
was on view from January 17 through March 28, 1999.

Available through D.A.P./Distributed Art Publishers
155 Sixth Avenue, New York, N.Y. 10013
Tel: (212) 627-1999 Fax: (212) 627-9484

Library of Congress Control Number: 00-109367
ISBN: 0-934418-59-4

Front cover: Detail, *Study for Portrait VII*
(Number VII from Eight Studies for a Portrait)
Page 1: Detail, *Study for Portrait V (Cardinal V)*
Page 6: Detail, *Study for Portrait V (Cardinal V)*

Photography by Philipp Scholz Rittermann
Publication coordinated by Andrea Hales
Designed by Susan E. Kelly
Produced by Marquand Books, Inc., Seattle
www.marquand.com
Color separations by iocolor, Seattle
Printed and bound by CS Graphics Pte., Ltd., Singapore

Support for this project was provided by:
AT&T
California Arts Council
Federal Council on the Arts and Humanities
Sue K. and Dr. Charles C. Edwards
Virgin Atlantic Airways
Lucille and Ron Neeley
The British Council
A & B Bloom Foundation